Sonnet's of Love and Life

EDWARD KIMBROUGH

authorHOUSE®

AuthorHouse™
1663 Liberty Drive
Bloomington, IN 47403
www.authorhouse.com
Phone: 1 (800) 839-8640

Published by AuthorHouse 10/08/2015

ISBN: 978-1-5049-5443-3 (sc)
ISBN: 978-1-5049-5442-6 (e)

"LAST NIGHT I SAW YOUR FACE"

Last night I saw your face, so wonderful, fresh and clear.
And all that pass through my mind, were the times we had so dear.
You look to be so close to me as if I were at home.
So now I know just how it feels to be so all alone.

I wonder if there'll come a time, when I'll see your face again.
And if there is I'd like to know, will we be more than friend?
I remember the fun we use to have, together just you and I.
And when I think of how it ended I often ask God why.

I saw your face last night, a wonderful sight to see.
So I thought to myself; can this loneliness really be?
I sit here and think if there's a way I can keep from feeling alone.
Yet I often wonder to myself, will I feel that way at home?

I think of oh so many ways to enjoy your lovely sight.
Now that every time I end the day, I see your face at night.
So let me end this poem, by saying what I really mean.
I saw your lovely face last night…AND I WISH IT WERE NOT
A DREAM.

"ONE MAN'S DREAM"

We are the guardians of this world god has given.
The keepers of the peace; that makes life worth living.
In order to make sure that life on this world can last.
We learn from and except our mistakes of the past.

We are the protectors of even the smallest child,
the caretakers of the sick and elderly
We must respect and believe in all of mankind,
never judging nor blaming.

We are the guardians of this land we walk on,
the planters of the seeds that make life grow.
Man grows the food that feeds the world
and all its living things.

So cherish this life and make it the most wonderful time,
for one and for all.
Because I believe in you, and you can believe in me.
But most of all I believe in…. one man's dream.

"PRISON LIFE"

Sometimes it's not so cruel, this world filled with strife.
Considering the way you live in the world of prison life.
When all I can do is ask the lord above, to help you,
keep you and bless the one's you love.

I heard someone say something about going home.
So I began to ask myself, will I be out there all alone.
I've lived one day at a time, for just about three years.
But every day of that time; my heart was filled with tears.

You sit and wonder if the woman you left will still be there for you.
And while reading your latest letter, she finally say (we're through).
She say; I can't go on this way, I have a life to lead.
So I have found someone else who can give me what I need.

So all you people out there, I know that you really care!
When you think about it and you say, that you can't finish the fight.
Just sit on the floor and close the door.
And think about …..PRISON LIFE.

"BEFORE I GO"

Give me the time; to say what I need to say.
That I'll always love you, forever and a day.
You are the air I breathe, and the only reason I have to live.
And I thank the lord for you and the time he gives.

I often take for granted, some of the things in life.
Like having you close to me and never making you my wife.
Forgive me for my mistake and the pain I sometimes bring you.
Now I can tell you; I finally know what to do.

I will love you and keep you oh so close to me.
I will hold you and cherish you, through all eternity.
So these are the things I really want you to know.
And I thought I should just say them; before I go.

"CHOICE OF WEAPONS"

Sticks and stones are hard on bones,
aimed with angry hearts.
words can sting like anything,
but silence breaks the heart.

Hate is a tool used to kill the soul.
Breaking down man's spirit, like a fine glass bowl.
Violence is the most deadly when you're in a fight.
For with this choice, anyone can destroy life.

So if you think the choices you make really can't last.
Just look to all the ones you have made in the past.
Then remember why we were created by the lord above.
To show each and every one, God's unconditional love.

"DREAMS"

Holdfast to dreams for if they die.
Life is a broken-winged bird unable to fly.
Holdfast to dreams for when they go.
Life is a barren field frozen with snow.

Your dreams are the visions of what life can be.
Joyous and happy though all eternity.
So hold fast to dreams, never let them slip away.
For they are the tools to make tomorrow a brighter day.

When children sleep, they dream of wonderful things.
Like hundreds of toys and giant cones of ice cream.
So hold fast to your dreams and you will see.
Just how wonderful and exciting life can really be.

"WISH"

As you come in to this world you will see.
There are all kinds of things here for you and me.
There are stores to shop and cars to ride.
Places to play and places to hide.

You can watch the stars, or see a show.
You can even do things, which only you will know.
I have done all sorts of things in this life of mine.
Some were wrong and some were just fine.

This world has been rough and sometimes blue.
It has even been wonderful and sometimes true.
I have met all kinds of people in the places I've been.
Some have been enemies but most have been friends.

So if you believe in a world true and free;
as I believe in you and me.
Then pray to God, to end suffering and strife.
And wish everyone a happy and wonderful life.

"TO HAVE AND TO HOLD"

My life was so lonely and oh so blue.
Until the day came that I met you.
I had no desire to see the morning skies.
Then the beauty that is you, passed before my eyes.

My days were dark and my nights were cold.
Every second that ticked away, made me feel so old.
You came into my life and made it feel brand new.
Charged my soul and spirit with a love so true.

Now I feel the love, contained in your smile.
And the happiness that holds me all the while.
So now I think it's time the world be told.
That on this day I take you....TO HAVE AND TO HOLD!

"MY LOVE FOR YOU"

For once in my life I have found someone;
with whom I can always be true.
And with all my heart I wish to say,
that baby I'm glad it's you.

The times that we have are so very special,
times that I hold so dear.
I want you to know that no matter what happens,
my love will always be near.

But as long as I know you will always be true;
then these feelings I can truly show.
There is, no greater love I know.
Than this love I have for you.

"TIME"

I sit and wait for my feeling to change.
Yet everyday they remain the same.
I am lonely and blue, while you're away.
And instead of blue skies, mine are cloudy and gray.

When you are near the sun warms my soul.
Your smile and your kisses they make me feel whole.
Now every day of my life, feels so complete.
And the angel's whisper, saying everything's sweet.

Now I've found someone who fulfills my every need.
And now I know that you are the very best of me.
So as the clock ticks, I pray you'll always be mine.
Now and forever, until the very end of time.

"BEAUTIFUL LADY"

I see the midnight stars when I look into your eyes.
And I feel my heart begins to soar across the sky.
When you're near me the world seems to stand still.
And when you touch me, my feelings become so real.

I see your face when I close my eyes at night.
When I think of you, I feel that everything is going to be alright.
The warmth of your touch makes me feel at home.
And I want you to know, you will never be alone.

So this is for you, the one I truly adore.
My beautiful lady, now and evermore.

"LOVE"

We cannot live accept, thus mutually.
We alternate aware and unaware of the reflex act of life,
and bare our strengths and virtue's outward most impulsively.

Full of knowledge and most instantly compelled to assert,
we live most of our life believing whoever breathes the most air
and counts his dying years from sun to sea, shall be free of choice
the path his life shall lead.

But when a soul by choice and conscience dote throw out his full
force on another soul the conscience and concentration both make
mere life, love. For life is perfect whole and aim consummated is
love in sooth as nature's magnetic rounds pole to pole.

"MY PRIVATE WORLD"

In my world there is peace and love.
The way it was intended, by the lord above.
There is no hate, there is no blame.
Only the burning of a lasting flame.

In my world everyone is free.
To do what they will, whatever it maybe.
It's not so cold and never any crime.
Only happiness, with safe and wonderful times.

The way things are in this world today.
Makes me wish to the stars there was another way.
So if you need a happy place to be.
Step into my private world and hangout with me.

"ON THIS DAY"

There are things in life that we hold most dear.
A kiss, a touch, a special word that we hear.
Every day of our lives can be filled with joy from heaven above.
Especially when you share them with the one you love.

There are time when you'll find, someone who believes in you.
And I just want to say, baby I'm glad it's you.
So let me tell you how our life will be.
Happy and joyful through all eternity.

Yesterday I was but one. Now today we are two.
In a world of our own, just me and you.
So I give you my love, in every way.
Now and forever starting......ON THIS DAY!

"LOVER'S DREAM"

I dream of the time of day when I will see your beautiful smile.
And the tenderness and joy you have shown all the while.
I dream of a day when we become close.
With all the things we share the most.

There are things I dream of and wish would come true.
For life to be filled with happiness, no-one to be blue.
For the world to be a safe place for our children to play.
To be able to have good times each and every day.

To walk in the grace of the lord above.
As he blesses this world, for the children he loves.
I dream of a time, when all God's children are free.
And, I dream of a sky as blue as the sea.

I once sat alone, not thinking of anything.
But, all I think of now, is the lover's dream.

"THINKING OF YOU"

Yesterday I was a child playing in the rain.
So full of myself, never feeling pain.
So cheerful and happy, not a time was bad.
I was as happy as could be, never feeling sad.

Today I am a man and so all alone.
Thinking of how it's been since you've been gone.
I sit in my room, not knowing what to do.
Sitting alone just thinking of you.

I wonder how you feel, since we've been apart.
And I ask myself, is there loneliness in her heart?
Maybe the heavens thought this was meant to be.
But did anyone up there, think of what you meant to me.

Well now I sit around, so lonely and blue.
Just hoping, praying and thinking of you.

"MY DREAMS OF YOU"

I would sit alone feeling blue.
Then I would begin, to think of you.
The way you move, and the way you walk.
Your lovely face, the way you talk.

Sometimes when I'm sad and feeling down.
I think of how things are, when you are around.
The times we have just you and I.
Filled with joy, under the beautiful sky.

At times I am hurt and oh so sad.
Then I remember the good times we had.
So when I'm alone and feeling blue.
I just kick back, relax and dream of you.

"THE WAY I FEEL ABOUT YOU"

My love grows stronger with every passing day.
I long for the moment to hold you kiss you and say.
You are my love, my life, my everything
When you are near such joy you bring.

Even though you're so far away, my love will always be true.
Because you see, there's no stronger love, than the love I have for you.
The days without you, seem like years.
Thinking of the moments we shared still brings me tears.

If it takes forever, that's how long I'll wait.
We can't change what happened, for fate is fate.
I love you, and I know you love me.
So our love will continue through all eternity.

"THIS PLACE"

In my mind there is a place I go.
A place that only my dreams can show.
In this place, the sky is always blue.
It's always filled with visions of you.

This place of warmth, where it's never cold.
A place that fills and warms your soul.
It brings me joy with visions of your lovely face.
Blessed by the heavens, and filled with God's grace.

In my mind there is a place I see.
Filled with joy and happiness for you and me.
In my mind I see a place so new.
In this place, I'll spend eternity with you.

So weather I'm sleep or wide awake.
Your kiss, your touch, takes me to this place.

"WITH THIS RING"

In my lifetime I have never seen, a woman as lovely as you.
Not even in my dreams, would I find someone so true.
I have known loneliness, what it means to be alone.
Without someone to talk with, all on my own.

But now that I've found you, oh how my life has changed.
My skies are clear and blue, no more standing in the rain.
Joy and happiness for me, are a new way of life.
So on this day I tell the world, I will make you my wife.

I'll spend my days just holding and loving you.
Make this promise to God, I will always be true.
So just to show you just how strong my love will really sing.
I give you my heart, my love, my soul with this ring.

"YOU ARE"

You are the sun that warms my soul on a cold November day.
You are the song that fills my heart, with every word you say.
You are my joy; strong, tender, considerate and true.
The reason my gray skies have all turned blue.

You are caring and thoughtful, a very true friend.
The reason I wish the days with you, would never end.
All the things you are, from the time your day starts.
The one thing I know more each day, is you are my heart.

So no-matter where I go, near or far.
Everything I am, the best parts of me….YOU ARE.

"WHISPERS IN THE DARK"

I dream of things that sometimes come true.
There are places that often remind me of you.
At times in my life, I feel so all alone.
And there are the days, when I'm glad you are home.

We sit and we talk, about how thing should be.
I thank the lord above, for bringing you to me.
My life would be so empty, meaningless and blue.
If I had not been blessed with being with you.

Our children are the gift in my life that you gave.
And I your debt I will be, for the life that you saved.
So as long as you're here, I will always have that spark.
I need you, I love you, are the words I whisper in the dark.

"SWEET LOVE"

Sitting here all alone, thinking of what use to be.
Remembering the good times together you and me.
I wonder if time, will bring you back my way.
And if it does what can I do, just to make you stay.

We were so good together, in the days past.
Oh how I wish so very much, that those days had last.
I was wrong to let you go, how I wish you were here.
To hold you, to kiss you or just to have you near.

You brought joy to my life, and brightened up my day.
Heaven knows I'll always love you in each and every way.
So I wish and I pray to the stars and the angel's above.
And ask the lord in heaven, to return my sweet, sweet love.

"THE RECIPE OF LOVE"

First you take a little friendship.
Divide between the two.

Then you take a pinch of sharing.
Just a little will do.

Now you take a dash of caring.
To help you on your way.

Then you add a sprinkle of joy.
To brighten up the day.

Now you pour in some pleasure.
To make it oh so sweet.

Whip in a cup of tenderness.
To make your dish complete.

Now you have the gift.
Sent from the heavens above.
The one and only total.
Recipe of love.

"VISION'S"
(FROM CHILDHOOD TO LOVE)

As a boy I played with toys, and other childhood games.
Never wanting to grow up, or for life to change.
Playing games like cops and robbers, and hide & seek.
All day long at home and play, until I went to sleep.

As a teenager when I awake, this is how my day begins.
Going to school to study and learn, hanging out with friends.
Running around all day long, without a care in the world.
Until the day came, when I finally discovered girls.

Now I'm a man confident and strong, no longer stirring into space.
The visions I see when I open my eyes is the sight of your lovely face.
There are time when I know, just what I want to do.
One is for, the rest of my life, to spend that time with you.

My life is so special now, because you made me see.
All the love in the world, that you have for me
So no matter what happens just keep one thing in mind.
With all my heart, I love you and thank God for this time.

"WOMAN" (STRONG & TRUE)

If you really want to ask me, about this world today.
I would tell you without woman, man would have lost his way.
She is strong, loving, and so very true at heart.
That just her presence in the room set the world apart.

A mother's love can comfort you in your time of need.
A sister's friendship can help you become a friend indeed.
A daughter's love can help you choose your way in life.
A A wife's strength can make you strong, to battle the worst of fights.

A man in his life can do anything, if he's willing to try.
A man can make his mark on the world, before his time to die.
But in this world there is a fact that everyone will tell you.
That every man can be even stronger, with a woman strong and true.

"BLACK WOMAN"

She awakens with the dawn of the blue morning sky. Confident and strong, allowing nothing to sway her from her task at life.
She is the string that holds the family together, the bridge that we cross as we go through our day

Sometimes things get hard and difficult but she never blinks always keeping to the rode, even when she is being taken for granted.
Yet as time goes on she teaches us that no matter what life may bring, we can still succeed as long as we work to make reality.

So when I think that there is no way I can go on. I look to the past and see the present and learn.
And I see that there is no one who has held up to all that life brings and still comes out strong like you.
So today, I dedicate my life and my heart to you and say I truly admire you...BLACK WOMAN.

"WHAT LOVE CAN DO"

Open your eyes to what love can do.
A love so sweet between me and you.
Into my heart there shall come a day.
When I know your love will never stray.

Love, love, wonderful thing.
Love, love, what joy you bring.
Love, love, wonderful love.
Love, love, love, sent from angel's above.

Days have passed since you went away.
Never in my life have I felt this way.
This feeling you gave me has lasted so long.
Oh sweet love want you please come home?

Love, love, beautiful thing.
Love, love, what joy you bring.
Love, love, you made me see.
Just how beautiful true love can be.

"THEN THERE WAS YOU"

Once I saw my life dwindling away.
Then there was you.
There came a time when I had no place to stay.
Then there was you.

People in my life seem to come and go.
Then there was you.
Others use to look at me and say "he just doesn't know".
Then there was you.

But now my life is a joy to live.
Love and happiness is what I have to give.
Now my skies are sunny and blue.
And I can proudly say, it's because there is you.

"MY HEART AND SOUL"

I find myself alone and wondering, if this was meant to be.
The time we spent together the laughter that makes my heart,
feel wonderful and free.

I ask myself can this be true, the love I feel in my heart and soul,
the loneliness when you're not around the longing to have you close.

We talk, we laugh and the days are joyful, my gray skies turn blue.
The song that my heart sings, makes me feel brand new.
But he most important words to my song so true.
My heart and soul will always belong to you.

"IN THE MORNING LIGHT"

We see the things we do throughout our days of existence. And wonder if we really know what we are doing.

There are things that happen when the night comes. Some that are not within our control, yet we try to make them our own.

Life is precious, yet man has insisted on controlling the outcome of every creature's path in this world. And even though we think of ourselves as the smartest being in the universe.

We can never reach our full potential of human evolution, until we see the true meaning of life, in the morning light.

For as we reach out for the stars, we are trapped in our own selfishness, by the way we treat our fellow man. It is only with the kindness and gratitude to one another that we can show God that he has not failed with man.

So pick yourself up, love the life you have been granted by God, love one another and show our children that everything will be alright…. In the morning light.

"TWO HEARTS AS ONE"

We talked, we laughed and we fell in love.
Two hearts made by heaven above.
We walked through the park, remembering the days.
Our two hearts met at school, where we played.

As we grew older our love also grew.
Yours for me, and mine for you.
Now together we have a love so strong.
It seems that in life, nothing can go wrong.

As we move through time, both good and bad.
We'll always remember the good times we had.
Yet I know my job can never be done.
Till the day, our two hearts are one.

"THE WORLD IS CRYING"

I don't know what's going on, with the people of the world today.
Something must be wrong, for the children to cry this way.
I hear the people talk of war, things like hunger and pain.
But most of all I don't know what for is this talk about acid rain.

There are people around who need our help, to save the planet from dying.
From pollution, war, crime and hunger, I hear the world it's crying.
We are the children of the world, confident, brave and strong.
So tell me today my friends, how could things go so wrong?

We have to find a way for our children's sake, to bring the joy back to life.
To give them a time of happiness, safe from pain and strife.
So on this day make this pledge, never give up, and never stop trying.
Do all that you can to bring the world together, that's what the world is
crying.

"LOVE'S PAIN"

You said our love would last, that it would never end.
Oh my sweet lady, we were more than just friends.
I love you more than words can say, more than life itself.
Girl I beg of you; don't put my love on a shelf!

I found love and I lost love, a love I thought was true.
The best time of my life was when I had you.
My heart beats with passion, whenever you're near.
Oh how much I need to be with you my dear.

I can't seem to find the words to tell you what I really mean.
Every time I close my eyes, there you are in my dreams.
Love hurts so bad nothing feels quite the same.
I can't seem to fight, the tears of love's pain.

"WHENEVER I SEE YOU"

There are things in life that make it worth living.
Like the time people share, the joy of giving.
Precious things you know you must keep.
The laughter of children playing in the street.

The first time I saw you, was just like a dream.
Especially for a man, who thought he'd seen everything.
There you were a vision, from heaven above.
Flown down from the stars on the wings of a dove.

So I enjoy the things that life gives to me.
I praise and thank the lord, for everything I see.
God has blessed this world, with the things he do.
But, my world comes to life, whenever I see you.

"DEAR MOTHER"

DEAR MOTHER;
I grew up admiring the way you raised,
12 children with strength and love.
Depending on no one, except the love
and grace of the lord above.

Things were hard at times, yet you may a way.
To care for and nurture us, each and every day.
You had to be, father and mother, experience joy and pain.
Accepting the good and bad days, through sunshine and rain.

Now I am a grown man, with children of my own.
Still learning the lesson's, only you could have known.
I had to find out for myself, everything you taught was true.
About the pain and love a true parent goes through.

Now my children are grown, and making their own way.
With the lesson's you taught me, to help make it through the day.
So with all my heart, I'll be honest and true.
Dear mother: from the depths of my soul I will always love you.

Dedicated to all the mothers of the world, especially mine.
Mrs. Lottie Lee Hicks (Kimbrough)

"ONCE IN A LIFETIME"

There are things in life that come around from time to time
Like people who think the way you do, the taste of good food or a fine
wine.
Sometimes we see things in real life that we once saw in a dream.
Or have a conversation twice, to get our point across it seems.

But the most important things in life come around once in a while.
Like parenthood and the true and unconditional love of a child.
Or the true friendship of someone you can trust with your life.
And that special woman, you choose to make your wife.

But this is the one-thing; you must always keep in mind.
A soul-mate, true love comes but once in a lifetime.

"PLEASURE AND PAIN"

I can't seem to get you; out of my head.
The pleasure we shared as we laid here together in bed.
I can't seem to get back into the light.
The pain you caused when you walked out of my life.

I go to sleep at night with dreams of you.
And awaken each morning, to a world so untrue.
You said you would never leave; you would always be by my side.
How was I to know your words were only lies?

So every day I ask the lord over and over again.
To help my heart survive, both the pleasure and pain.
The memories of you, that seems to haunt me every night.
The hurt that seems to drain; my strength and my might.

I can't seem to get you out of my head.
The please that we shared as we laid here in my bed.
I can't seem to get you off my mind.
The pain that devastated my heart, because you left me behind.

"I CHOOSE YOU"

Your beauty amazes me, the smooth soft feel of your beautiful brown skin, the sparkle that shines in your lovely eyes and the shape of your sexy body that looks as if it has been blessed by God not once but twice.

Every night when I close my eyes to sleep, this is the vision in my dreams. Yet it is your personality that attracts me to you, your intelligence lets me know that you are a strong and confident woman and that's what I need in my life.

Your since of humor assures me that the time we spend together will be joyful and fun, I have spent my entire life searching for a woman who can make my life complete, and today sweetheart I can truly say, that's why I choose you.

My heart sings when you are near; the spirit in me soars with every syllable from your sweet voice. I have known women in my time but none have captured my heart like you.

In this time of uncertainty, when it becomes hard to believe in mankind; you are the one person I can count on to keep my soul content and darling that's why.......I CHOOSE YOU.

"A CHOICE TO LOVE"

*I see the sparkle in your eyes and feel
the tenderness of your touch, so I make
a choice to love.*

*The pain and fear in my heart tells me to
stop and back away, that only hurt can come
from what I feel inside.*

*Yet every word that comes from your sweet
lips sooths my aching soul and feels my spirit
with excitement, so I make a choice to love.*

*Thoughts of broken promises and faults words
Invade my heart to protect me from myself
and the pain of love.*

Saying that the only one I can truly depend
on is myself and that love is a mistake that
only fools can afford.

But when I see your beautiful face, I once again
believe in the grace of God and know that he
bought us together, with the love
he has for us.

So now I have been graced with your beauty and
the sweet kiss of your soft tender lips, I make a
wish, I make a choice to love.

"THROUGH OUR CHILDREN'S EYES"

Bunny rabbits, puppy dogs, ice cream and balloons.
This is the world as it's seen through a child's eyes.
Hatred, greed, fear and lies. these are the emotions
that control the majority of our adult lives.

Brother's; both black and white we have become
absent, not just in our children's lives but as men
in the world. Mother's, daughter's you have be come
complaisant, it is time to take back the control you
gained when you became women, not a slave to man.

Honor and glory awaits us in our father's house. But,
we must regain the respect we had and learn to believe.
We must have faith in the lord, cherish our lives and
remember the way things look, through a child's eyes.

Our most precious treasure's are not the material
things we leave behind, nor is it the wealth we gain
throughout life. The legacy we leave behind are the
children who will inherit God" beautiful world.

So don't be afraid to embrace your faith and always
remember how the world looks......through our children's eyes

"AS WE BECOME"

I am a man strong, confident and true at heart,
seeking someone to love.. My one true love,
to whom I can give my all.

You are woman; independent, loving and caring
seeking that one true heart that trusting soul
who will always be there to catch you should
you ever fall.

We search the four corners of the world, yet
not finding each other. You are dissatisfied
untrusting of man, I am lost hurt by women
who use and control.

I see you in the distance and know, we were meant to be.
to be together. God has brought us to each other, to
fulfill, care and love one another on this day...........AS WE
BECOME ONE.

"ONE TRUE LOVE"

My soul sings, my spirit soars and
I am a happy man.
My heart jumps for joy, and
I am a happy man.
And it's all because of you, my one true love.

My mind fills with excitement,
laughter envelopes the room and
I am a happy man.

God's grace surrounds us, his love
and our love keeps us together and
I am a happy man.

Today my life is complete, filled with
Joy, love and happiness and it's all
because of you my........ONE TRUE LOVE.

"GOD HAS EARS"

Let me tell you something about this world.
The harm some people cause our children
we hold so dear.

God has eye's; the lord can see the hurt
and pain we suffer at the hands of our
fellow man.

God has hands to hold us securely in his
love and grace. It is this love and grace
we feel when we awaken each morning.

To see the morning sky, feel the warmth
of the sun and hear the voices of the
one's we love.

So just like when you praise him and
speak kindly of man.
When you say hateful things and lie
to hurt someone remember.

GOD HAS EARS, HE CAN HEAR YOU!

"NOT ALONE ANYMORE"

Nights so cold it seems no matter
how much I cover up I just can't
seem to get warm.

Skies so gray the sun can't seem to
shine through or break the grip of
dark clouds that cover the day.

I know what it is to be alone, to
have no-one to talk to, no-one to
hold at night or kiss each morning.

I know what it feels like to be all
by yourself, sitting home looking
at the walls wondering when love
will come your way.

Today God sent me an angel,
a voice soft and gentle, lip
sweet as honey.

A beautiful vision to see, she truly
loves me and I am not alone anymore.

"DON'T CALL ME THAT"

I am just like you, I work hard to get the things
I have and take care of my family. You call me nigga
and boy, then you think these are terms of endearment.

These are the words that were used to belittle and degrade
our fathers and mothers, our grandfathers and grandmothers.
They meant you were the property of someone else and you
had no rights as a human being, so don't call me that.

Our time will come when we will leave this world to the
next generation of men and women.
Now we have trained them that these words are okay just
as long as the person saying them has the same skin color.

I raised my children as I was raised, to know we are a proud
race of people capable of doing anything we put our minds to.
There are people of our race who have created things like the
cotton gin, peanut butter and the artificial heart.

Yet we use derogatory words to describe ourselves as well as
our beautiful mothers, sisters and daughter.
So my brother; my friend I ask this favor of you. Give me the
same respect that you ask for and don't call me that.

We are the people of a proud and majestic culture. So when
you see me as I see you, we should see the kings and queens
of that culture, so don't call me that.

We are the builders of a nation and the foundation of a world.
Without us there would be no homes to live in, no cars to drive
and no roads to drive upon.

The derogatory words we teach our children such as nigga, bitch
and whore, these are words that can destroy a nation.
So stand up, be proud of your heritage and tell your fellow man.
Have respect for me as I have respected for you and.....DON'T CALL
ME THAT.

"FRIEND"

When I need someone to talk to you are always there.
When times get hard, you are here to let me know,
that someone does care.

We kick back and hangout like partners do.
Through thick and thin, friend to the end
dawg's tried and true.

When things go down I got your back,
just like you've got mine.
Inseparable friends we will be, until the.
end of time.

So this is my pledge that I will keep, until
time's end.
I will always be there you can count on
me, your partner, dawg, friend.

"ALL IN A DAY"

Joined hand in hand making our way, through this world.
One boy who is in love with just one girl.
I look in your eyes and they show me a true love.
I hear your voice and it make my heart soar to the sky above.

I feel the strength in you and I know that I can do anything.
And when you touch me it makes my soul want to jump and sing.
Today we share our world, yesterday we were apart.
Loneliness no longer resides in side my heart.

The sun, shine a feeling of warmth whenever I think of you.
And happiness feels the world around me, when you do the things you do.
Song fills the air every time you are near.
And all I want to ever say is that I'm glad you're here.

I think my life, came to be when you came my way.
And what is so amazing is this is just, all in a day.

"CLOSURE"

*Taking this time to say good-bye, although
we have had some good times I can't forgive
the pain you caused my heart.*

*I thought you were the one, the one who
Would fulfill my every need and take me
to the next level.*

*Though we had some bad times I must
thank you, because you helped me realize
that my true love is out there and I have
to find a way to get back to her.*

*Even though your words were lies I must
tell you thanks for setting me free and
opening my eyes and giving me closure.*

"WHY"

Each night when I close my eyes I ask the
lord above, dear God why?
Why does my heart feel this way?
As if it's been ripped out, slowly each day.

Why did I believe in her, and listen to every word.
Now I'm left here feeling so all alone and scared.
Why is it her heart was so very untrue?
And when I was so sure, that she was sent by you.

I have searched so long for one true love.
Yet it never seems to find my heart.
Searching the heavens, and praying to God above.
And the only things that happen, is my world gets torn apart.

I can't seem to understand, why things have to be so bad.
Why is it, my life has to be so sad.
I wake up each morning, feeling like I want to die.
Lord in heaven, won't you please tell me why.

Why it is the thing you want, aren't the ones you get?
Why is life such a gamble that you wish you hadn't bet?
Why does your heart have to feel, such awful pain?
Why are there days I'm left standing, here in the rain?

I envisioned my life filled with joy,
my spirit soaring through the sky.
You played my heart like a toy,
but you never tell me why.

So the next time someone, comes into my life.
I will walk with care, and not be blinded by sight.
I will hold my head up and look to the sky.
And at that moment I will ask God; why?

"HAPPINESS FOUND; HAPPINESS LOST"

Excitement in my heart, joy and happiness at the sight of her. She is everything I want beauty, intelligence and sensitivity, my emotions run rapid, I am crazy about her nothing else matters.

She says everything I want to hear, but my emotions tell me something is wrong. But that doesn't matter to me, she is everything I need. I hurt from past relationships, land-minds that break into my heart rip it apart.

She comes and eases that pain, making life worth living again. I awaken this morning to find my heart on the floor and broken once again and I hear those words for the second time. I am not in love with you I am in love with what you can do for me.

The words pierce my heart like a poison arrow and I realize happiness lost. I fight the thought that this could be happening again, so I ignore the signs and cloud my mind with the memories of when we first met, happiness found.

My memories of her touch feels exciting, even the thought of her kiss ignites my heart, so nothing else matters. I can't wait to be by her side and hold her in my arms.

Now we are together and things are not the same, she hardly speaks to me and her touch no longer exists. So I tell my heart it is to blame and once again happiness lost.

Better off alone; but I know there is love for me out there, somewhere.

"THE LOU" (ST. LOUIS)

I have been to cities all over this country, but I still come home.
There have been good and bad times, but still I come home.
I have seen beautiful women, from all walks of life and places too.
But none have the beauty and spirit, like those in "The Lou".

My heart is at ease, my spirit is calm and my soul is no longer alone.
So no matter where I go or what I do, I will always come back home.
When I am down in spirit and kind of feeling blue.
I will always know, all I need is to get back, back to "The Lou".

So here I am in a new place, trying to settle in.
Starting over, building a home and making new friends.
So I take the time to remember this place, the home in which I grew.
For no matter where I go to make a new life, my heart is always in "The Lou".

"DADDY'S GIRL"

My life truly began the day that you born, just one
of my reasons for living.
I felt so much joy when I saw you, thank God for
the gift he's given.

As you grew up I gave you my heart, my love my
strength and my all.
To make sure you know I would always be there
to catch you when you fall.

Now you've become a woman courageous, true and strong.
The beautiful daughter I knew you would become all along.
As I've grown older in my life, you've always been there for me.
So that's why no matter where you go, Daddy's Girl you'll always be.

(I love you princess)

"MISSING YOU"

There is a pain that sits here in my heart.
It has been there since we broke apart.
I wish you were here with me, sharing love so true.
But today I am really just, missing you.

I remember sitting in the park under blue skies.
How excited I was just to look in your eyes.
Your beauty and your touch, warms me like it always do.
That's why today, I'm just missing you.

The sound of your voice, still ignites my spirit and my soul
The beauty that is you, is what I long to hold.
I know I've messed up sometimes and my mistakes are all but few.
But when I close my eyes at night, lord knows I'm missing you.

You are the heart of me, the air that I breathe.
The worst pain I ever felt, was the day I made you leave.
I spend my day trying to figure out what to do.
And I spend my night just missing you.

So if you come back to me, I promise I'll always be true.
I wonder if you're missing me, because I am missing you.

"BEAUTIFUL ONE"

They say that beauty is in the eyes of the beholder.
And I believe for you are a beautiful sight to behold.
Every morning I awaken with the thought of seeing you.
Then you arrive and I don't know what to do.

I sit back and think what can I do, what can I say.
And hope just one time you'll look my way.
You are more beautiful than a bright sunny day.
Every time I see you, my heart comes out to play.

So I wrote this for you, and believe me it's real.
I've come to know everytime I see you, this is how I feel.
Oh how I want to hear the sound of your sexy voice.
Then pray to the angels, that you'll make me your choice.

So now that things have come to light, I say this and be done.
You can always be sure that I think you are that beautiful one.

"BEAUTIFUL WOMAN"

I wish I were the sun, I would rise every morning jus to shine on you.
No clouds or rain would enter the day, to obstruct my view.
If I were the stars I would light up the midnight sky to brighten your way.
As you come in to relax from the pressures of the passing day.

They say that beauty in in the eye of the beholder of this I have no doubt.
For I see the beauty that is you both inside and out.
The lord has said; good things come to those who wait.
So I go through the day trying not to make a mistake.

The mistake is to rush into things, never seeing what it really means.
Instead of searching my heart for the real you, not just a dream.
So I search the world over, time and time again.
Hoping to find the ultimately true…..beautiful woman.

"MEANT TO BE"

I know what it's like to be without you, my heart beats
a little slower. The days and nights are longer it seems
to rain each and every day, I am so lonely.

Every day I pray that god will bring you back to me, but
my prayers go unanswered. So my heart remains broken,
I love you with all my heart and soul, with every fiber of
my being.

There is no one in this world who can take your place in
my life. If I can't be with you, then I will spend the rest
of my life alone. Only you can make my life complete.

I know all of this, sounds like the talk of a crazy man,
but I can only tell you what's in my heart. That this
is how I feel. When I think of you, my heart skips a
beat, you make me laugh you make me smile.

And though there are times when we fight and I
make you mad as hell; I know my life is nothing
without you. I know we were meant to be.

"HEAVENS STAR"

Eye's that sparkle!
They can only be compared to diamonds.
A smile so beautiful and bright!
It is only out shined by the morning sun.

I have watched you day in and day out.
Now I truly believe I know what love's all about.
Beauty that become the light of my world.
For now you are woman, no longer that shy little girl.

Skin so soft and smooth!
It's a joy just to hold you in my arms.
You touch my heart with your heavenly charms.

A personality that lights up the sky!
I can see the beauty that's in you; it makes you who you are.
That's why I know you were sent from above, you are heavens star.

"BEAUTY"

I first saw her face as I walked down the avenue.
Never letting her leave might sight.
Watching her glide, as she walked away.
Never realizing, that day had turned to night.

She turned and looked back and gave me a glance.
I felt as though she could read my mind.
Thinking to myself, if I only had the chance.
I would make her mine for a lifetime.

I saw her face, as she walked away.
This vision had taken control of me.
And I knew at that moment, that she would be mine.
This lady, this woman, of grace and beauty.

"IN MY DREAMS"

I use to close my eyes at night,
and be afraid of the day to come.
But then came you my love,
sent down from heaven, to show me what life becomes.

It seems as though the hurt and pain of before,
was always there and would never go away.
Always banging at my door,
calling for me, each and every day.

But now I close my eyes at night,
to awaken and start the day, a brand new scene.
Because god has sent you to me.
The woman in my dreams.

"MY LOVE"

I give you my heart!
Because every day you make me smile.
I give you my spirit!
Because when I am near you, you lift me up keeping things in line.

I give you my soul!
Because god has blessed it with you, as its mate.
To care for and love!
Which it gladly takes on faith.

But with every fiber of my being!
And with all the blessings from heaven above.
I give you all of me!
Including...........MY LOVE.

"I DON'T KNOW"

I don't know what I would do if you weren't in my life,
chasing away the pain.
I would probably be struggling with days filled with strife,
trying to survive the strain.

You give me hope and you make my life worth living,
you help me understand.
With you I know that no matter what happens,
I can be a better man.

I don't know what I would do or where I'd go,
without you by my side.
Or even if I'd be able to hold my strength,
or contain my foolish pride.

I don't know why I was blessed with you,
by the lord above.
But I do know each and every day I will,
guarantee you my love.

"MAKE A STAND"

Make a stand for what you believe in,
let no one tell what you can't do.
For if you don't try you can never win.
As the saying goes, to thine own self be true.

Make a stand for you want in your life.
For these are the things that make you smile.
Keep out all of the stress and strife.
Holding on to your dreams all the while.

So when things get hard and life gets tough,
and you need to make a plan.so pick yourself up,
kick your problems to the curb, dust yourself
off, stand up and …MAKE A STAND!

"THE RAP"

Hey baby, have I seen you before?
Maybe it was in a dream, or standing outside my bedroom door.
Can I get your number and call you, man you look so fine.
Yeah I know what you are thinking, here goes another line.

I live my life everyday searching the world, looking to see.
If I might be able to find, someone out there for me.
It seemed like every woman I came across was just something to do.
Then one day the angels above introduced me to you.

I tell myself I can only get hurt, don't open my heart that way.
But as we talk and I look in your eyes, we get closer every day.
Man I have never felt like this, so simply out of control.
But every time I think I'm losing it, your love reaches and grabs hold.

I know there are a million things, I can say or even do.
But the best "rap" I can use is, my heart, my soul and my spirit
It all belongs to you.

"ME"

Who am I?
I am a man struggling to survive,
in a world so cruel and cold.
Wondering how I've managed to stay alive,
without anyone in my life to hold.

I am Gods child hoping for a day,
that won't be filled with pain.
Wishing that I could find a way,
to keep from going insane.

I am a father praying and scratching,
to keep my family free.
Free from all the pain and misery,
that once controlled me.

So as you read these words,
look in your heart open your eyes and see.
Our worlds may not be that far apart,
and you are just like me.

"IF YOU WERE ME"

I hear the children crying and I cry too.
If you saw the pain in their eyes, what would you do?
There's a world filled with people, longing to be free.
Tell me brothers and sisters what would you do, if you were me?

Would you reach out your hand to wipe away their tears?
Or would you close your doors and try to hide your fears?
I'm trying to figure out what it will take to make this world free.
So tell me brothers and sisters, what would you do if you were me?

Would you speak a kind word to let them know you're there?
Or would you walk on by, pretending not to care?
But by the grace of our lord God, this could be you.
Now tell me brothers and sisters, what would you do?

So open your eyes and look, out at the world we all see.
And tell me people, what would you do......IF YOU WERE ME?

"I AM"

I see the joy in your eyes, feel the caring in your
heart and I am grateful
I feel the warmth of your touch, the love of your
Kiss and I am thankful.

I have never felt the things I feel today.
Just the thought of you makes my heart beat this way.
It beats like a hammer, pounding on a nail.
It runs like a train, speeding across its rail.

I see the sparkle in your eyes, the happiness in your
smile and I am delighted.
I hear the charm in your voice, see the style in your,
walk and I am excited.

I have seen many things, chosen what I can.
but what I feel for you inside makes me who I am.

"I CHOOSE TO BELIEVE"

I see the world for what it is.
The sun setting on a cold world.
The night falling on an uncaring society.
Yet I choose to believe things can be better.

I only believe what my eyes can see.
Man taking advantage of his fellow man, children being
mistreated and abused and no one seems to care.
Yet I still choose to believe things can be better.

My life as a child was confused and troubled,
but I made it through.
As I grew to a man, I struggled and scrape, scratched,
and clawed to survive.

Now as you look back on this world so cold.
Thoughts flow through my head of when you were young and old.
Then answer this question my friend, with all honesty.
If you were me, what would you believe?

"MAN'S MISTAKE"

We believe that power means the control of everything and everyone.
When in fact the love of mankind is the greatest power of all.
You see happiness as being rich with money and material possessions.
When true happiness comes from the grace of god and the will of his call.

Man has the impression that we are the smartest creatures on this planet.
But, there are creatures smaller than us more powerful and smarter.
Man believes that he is the only being in the universe.
Yet he still reaches out to other planets.

God created man and all the creatures of the universe.
Man builds upon the land and believes he has the right to destroy it.
We live upon this world designed and created by our god.
But we still think we own it, this is man's mistake.

I was born July 15, 1959 in St.Louis, Mo. I am the 5th of 12 children 6 boys and 6 girls born to my mother.

I grew up with a love for poetry, and a deep respect for my mother and all women, a true romantic at heart, with a love and talent for singing but poetry has always been a true passion for me.

I am a caring and sensitive person, I have three children 2 daughters Jasmine and Leslie and 1 son Brian, who have always been my greatest joy. I am a Christian with a firm belief in the Lord. I now live in Texas and decided to share my heart with the world by sharing my poetry with everyone.....I hope you like them.